PAUL GAUGUIN

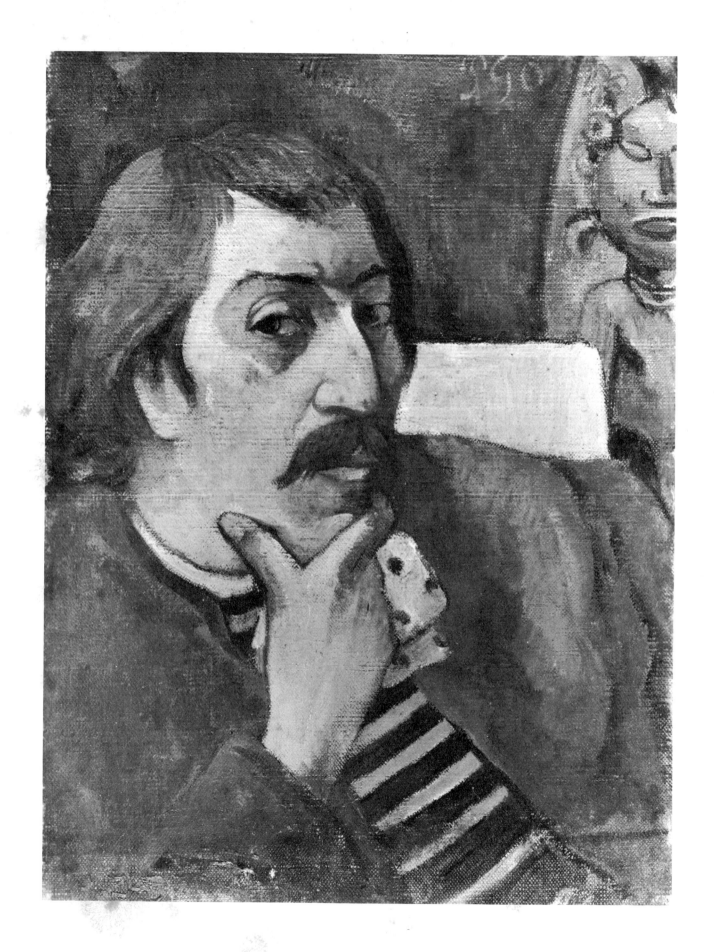

PAUL GAUGUIN

Alfred Werner
Art Critic, *The Reporter*

McGRAW-HILL BOOK COMPANY · NEW YORK·LONDON·TORONTO·SYDNEY

Cover picture, *Head of Tahitian Woman,* drawing. The Cleveland Museum of Art, Mr. and Mrs. Lewis B. Williams
Collection.

THE LIFE of Paul Gauguin, pioneer of modern art, was crowded with drama. There are painters and sculptors who live what are commonly called "uneventful" lives, a phrase which makes sense only if one does not consider the births of masterpieces events at least as significant as the turbulent and violent actions of a Cellini or a Van Gogh. Camille Pissarro, for instance, led a relatively quiet life that can be summed up in a paragraph or two, while his paintings require our full attention. His pupil Paul Gauguin, by contrast, after a dozen years of fairly conventional bourgeois existence started living in so reckless a manner that his career was to inspire novelists and movie-makers to melodramatic concoctions devoted more to his often astonishing behavior than to his rich inner life and his admirable achievements as a painter, print-maker, ceramist, sculptor, and writer.

At the same time, for an understanding of Gauguin's remarkable work it is essential to be familiar with his unusual history, for his life and art are most inextricably interwoven. When the successful stockbroker Gauguin made the fateful decision to risk his own security and that of his wife and five children in order to gratify his artistic compulsion, he changed completely the course of both his life and his art. Pissarro, who was content to work undramatically in little villages around Paris, suspected that Gauguin's journey to Tahiti was just a publicity stunt. The fever of travel was simply not in Pissarro as it was in the younger man who had, in his own words, "a terrible itch for the unknown" which could make him "do mad things." Yet those who called Gauguin a sensation-seeker — as they also accused him of being selfish, vain, cruel, commercial — might have considered the fact that, bafflingly, this brute was the most ardent exponent of the anti-realistic, anti-materialistic, metaphysical trend in modern art, and one whose key words were "soul" and "imagination."

This Eugène-Henri-Paul Gauguin was born in Paris, on Rue Notre-Dame-de-Lorette on June 7, 1848. A commemorative plaque now identifies the parental house. When he was three, his father, Clovis, a journalist opposed to the new regime of Louis-Napoléon (the future Napoléon III), went with his family into exile. Unfortunately, the elder Gauguin died on their voyage to South America. The widow and the two small children, Paul and his sister Fernande Marcelline Marie, found refuge in Lima, Peru, where they all stayed with Madame Aline Gauguin's uncle, who had once been viceroy under the Spanish colonial rule. After four years the Gauguins returned to France and settled in Orléans.

Paul attended the Petit Séminaire, a boarding school, but did not finish his studies there, knowing that he was not meant to be a scholar. Aged seventeen, as a pilot's apprentice in

Frontispiece.
*Self-portrait
with an Idol* (1890)
oil, 17¼" x 12⅞"
Marion Koogler McNay Art
Institute, San Antonio, Texas

[Facing this page]
Detail of Figure 18

5

the merchant marine, he made two trips to Rio de Janeiro, again setting foot in an exotic land. On a cruiser of the French navy, he sailed around the world, even stopping briefly at Tahiti, the South Seas island which was to become so important to him much later. After his term of service had expired, his mother arranged employment for her twenty-two-year-old son in a firm of Parisian stockbrokers. He did well, even prospered, and in 1873 married. His wife, Mette Sophie, daughter of a Danish Lutheran minister, gave birth to Emile, Aline, Clovis, Jean, and Paul. (Jean became a prominent sculptor in Copenhagen; Paul, who changed his name to the Norwegian "Pola," is known chiefly through a book on his famous father; Pola's son, Paul René Gauguin, is one of the outstanding graphic artists in Norway.)

It is generally believed that Gauguin turned to art in the middle of his life. Yet we know that he made a drawing of his bride as early as 1873 when he was only twenty-five. Even when his painting was still a "hobby," the young stockbroker, with his friend Emile Schuffenecker, employed by the same firm, went to the Académie Colarossi once or twice a week, to spend the evening drawing and painting from the model. With "Schuff" he visited the galleries and museums. He met Pissarro, who gave him some instruction. Gauguin, in turn, bought his master's works, as he acquired paintings by other Impressionists (then still a controversial group). As early as 1876 the "Sunday painter" Gauguin exhibited a landscape at the official Salon, the yearly exhibitions in Paris organized by the Société des Artistes Françaises. In 1879 he participated in a group show of the Impressionists. When two years later he joined the Impressionists for the third time, a nude painted by him caused the novelist Joris-Karl Huysmans to extol its "forceful note of reality."

The turning point came in January, 1883, when, to his wife's consternation, he suddenly gave up his job. He was then close to thirty-five. "From now on," he said, "I will paint every day." After his hopes to make a living as a painter had evaporated, he moved with his family to Denmark, in vain trying to succeed as the representative of a French manufacturer of tarpaulins and canvas blinds. His paintings were exhibited in Copenhagen, but were rejected as mad or immoral, and the show had to close after five days. He quarreled with his wife, and with her Danish relatives who disapproved of him, and finally returned to Paris.

Henceforth, his life was to be so crowded with dramatic events, many of them of a tragic nature, that only a few salient facts can be recorded here. Still unable to sell any of his paintings, he toiled for a while at starvation wages as a bill-poster. Accompanied by a fellow artist, Charles Laval, he embarked for Panama in 1887, hoping to "live as a savage" in the tropics; instead of finding a paradise there, he was forced to hard manual labor on the Canal. He went to Martinique, where he fell sick with malaria and dysentery. To return to France, he had to work his passage as a sailor.

Neither poverty nor illness ever stopped him from painting, nor from improving his manner and achieving greater and greater originality. Now and then he was able to sell a picture; but there were never enough sales to give him economic security. In order to

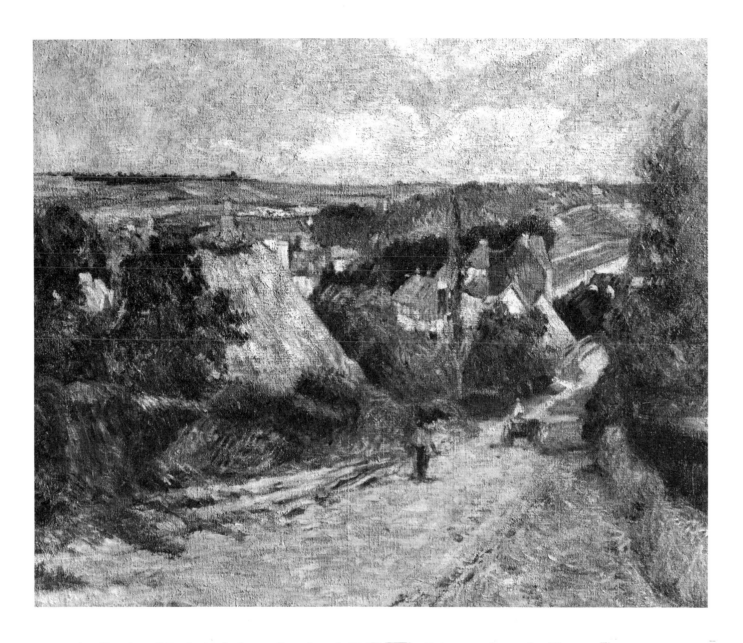

escape the disquiet of Paris, and also to live cheaply, he went to Brittany, where, dwelling near simple peasants and fishermen, in an austere, yet in many respects fascinating landscape, he produced his first truly original works, sharply different from his earlier, more or less Impressionist paintings. This was especially true of his second sojourn there after the West Indian failure. His visits, altogether four, in this then quite remote region would extend over months, and he became the leader of a group of artists from many lands who had also sought refuge there. These artists are often referred to as the "school of Pont-Aven," from the name of the Breton town where they congregated.

There was also a two-month adventure in Arles, Provence, in 1888 at the invitation of Vincent van Gogh. The two soon started to quarrel over problems of aesthetics. There were other reasons for friction too. One evening Gauguin saw Vincent coming for him with an open razor in one hand. Gauguin decided to spend the night in a hotel. The next morning,

Figure 1.
Entrance to a Village (1884)
oil, 23½" x 28¾"
Courtesy, Museum of Fine Arts, Boston.
Bequest of John T. Spaulding

7

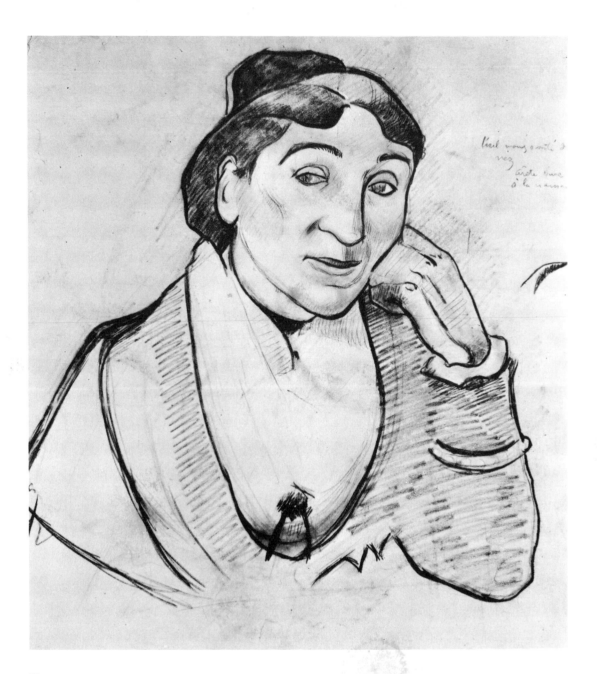

Figure 2.
L'Arlesienne (also known as *Mme. Ginoux*) (1888)
charcoal, 22″ x 19″
Collection, Mr. T. Edward Hanley, Bradford, Pennsylvania

Figure 3.
Still Life with Three Puppies (1888)
oil on wood, 36⅛″ x 24⅝″
Collection, The Museum of Modern Art, New York
Mrs. Simon Guggenheim Fund

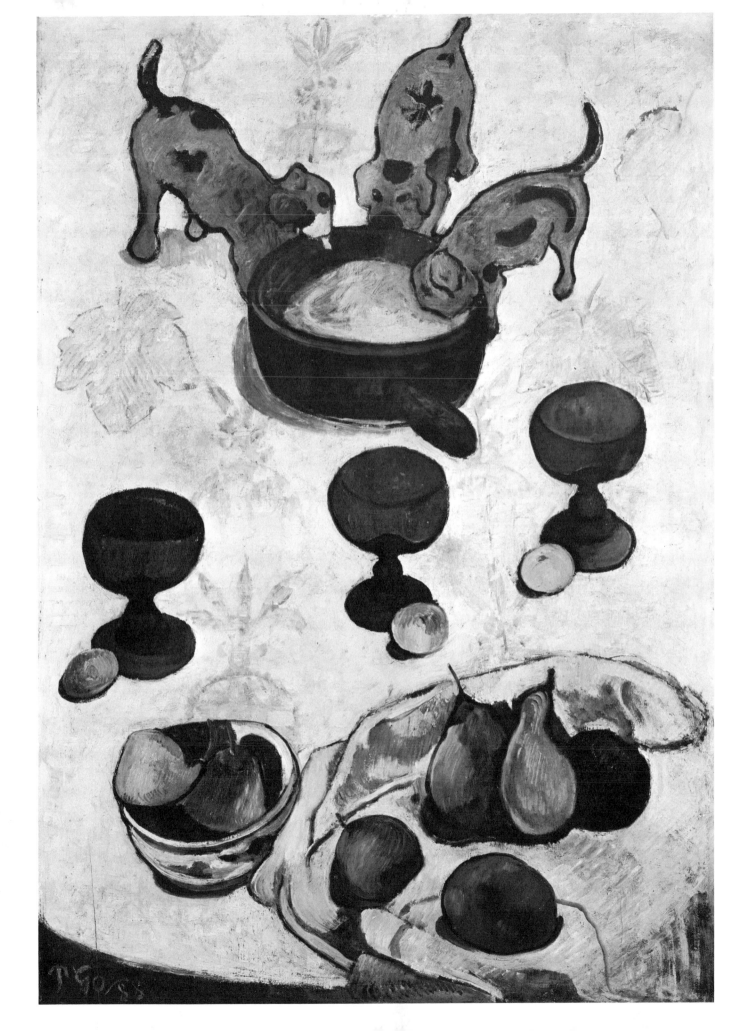

after having learned that Vincent, in a fit of madness, had cut off part of one ear, Gauguin took the first train back to Paris.

We have an interesting description of Gauguin from the pen of a Scotsman who worked with him in Brittany: "Tall, dark-haired and swarthy of skin, heavy of eyelid and with handsome features, all combined with a powerful figure, Gauguin was indeed a fine figure of a man. . . . He dressed like a Breton fisherman in a blue jersey and wore a beret jauntily at the side of his head. His general appearance, walk and all, was rather that of a well-to-do Biscayan skipper of a coasting schooner; nothing could be further from madness or decadence. In manner, he was self-contained and confident, silent and almost dour, though he could unbend and be quite charming when he liked."

Gauguin reminded another artist of "a fighter, a troubadour, a pirate. . . . Energy was apparent in his whole character; he seemed to brood over an enormous work. He had read much; the Bible, Shakespeare, Balzac seemed to hold the chief place in his affections."

One cannot resist speculating as to what might have become of Gauguin had he not left France for the South Seas. It is true that he had achieved some small success — along with aesthetic awakening — prior to his first stay in Tahiti. But those who applauded his efforts were largely a few avant-garde writers, and a number of artists younger than himself. The public at large jeered, if it came at all to his only one-man show arranged by the art dealer Theo van Gogh, brother of Vincent. A group show in a café at the entrance to the Exposition Universelle, the Paris World's Fair of 1889, largely composed of Gauguin and several disciples such as Charles Laval, "Schuff," and young Emile Bernard, was met with derision by the critics.

He knew that he must escape France, indeed the Old World, in order to realize his ambitious goals and make his personality felt at long remove. As is demonstrated in his work, it was only in Oceania that he cast off the last fetters of traditional art and continuing the search he had begun in the West Indies, in Brittany, and in Arles, became the Gauguin we know. To be sure, the freedom he sought was not the neurotic dream of middle-aged men who try to shed invisible shackles by a sudden and heedless revolt; the rejuvenation he yearned for was not that of Ponce de León, but one for his art, which, he knew instinctively, would grow drab and stale in a milieu that had become loathsome to him.

One cannot blame his wife, stranded in Copenhagen with her young children, for having failed to endorse her husband's decision. His friends did understand. On the eve of the painter's journey abroad, the critic Octave Mirbeau, wrote: "[Gauguin] flees civilization and voluntarily seeks oblivion and silence, the better to feel himself and the better to hear the inner voices which are stifled by the din of our passions and arguments." Mirbeau's article was reprinted in the Hôtel Drouot catalogue for the auction of Gauguin's pictures, and certainly enhanced its success. At a farewell banquet given by artists and writers in Gauguin's honor, a speech was made, and verses by the Symbolist poet Stéphane Mallarmé were recited.

Aged forty-three, on April 4, 1891, Gauguin left "this filthy Europe" from Marseilles

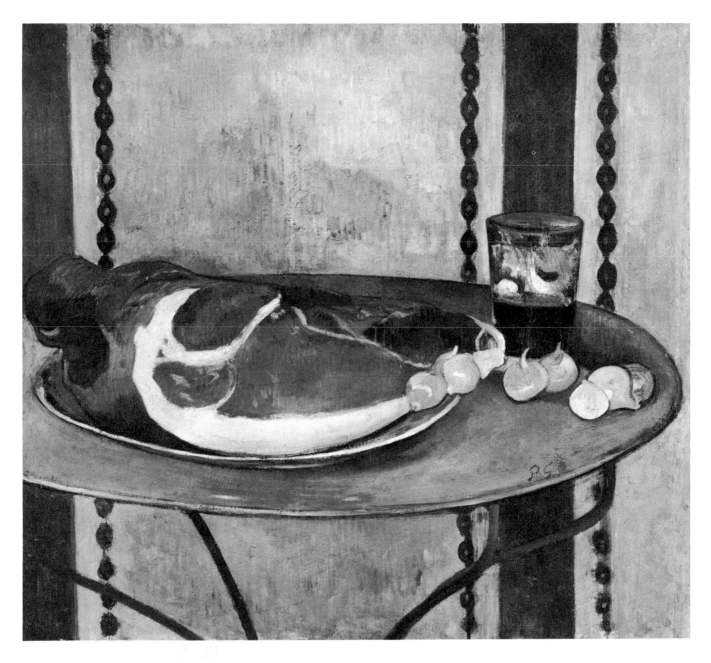

for the island of Tahiti. He was back in the same port city two years and four months later with only four francs in his pocket. He also had his paintings, for which he could find no buyers, but which are now the pride of public and private collections. How did he react to this faraway spot?

"There, in Tahiti, in the silence of the lovely tropical night," he wrote to his wife, "I can listen to the sweet murmuring music of my heart, beating in amorous harmony with the mysterious beings of my environment. Free at last, with no money troubles, and able to live, to sing, and to die. . . ."

In his journal *Noa Noa* (the term is the Maori word for "fragrance"), which was edited for publication by a friend, a literary man, there is no word about the often exasperating

Figure 4.
Still Life with Ham
(also known as *Le Jambon*)
(1889) oil, 19¾" x 22¾"
The Phillips Collection,
Washington, D.C.

Figure 6.
The Yellow Christ (1889)
oil, 36¼″ x 28⅞″
Albright-Knox Art Gallery
Buffalo, New York

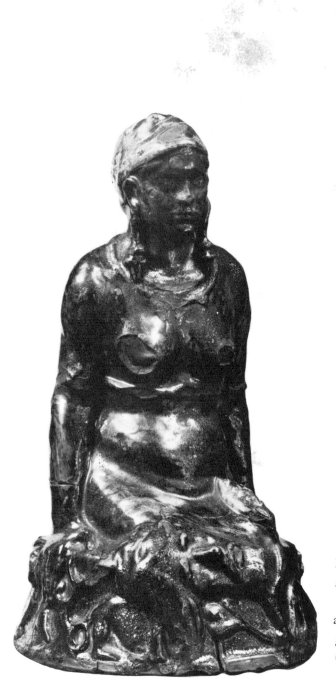

Figure 5.
Black Venus
(also known as *The Black Virgin*
and *Seated Woman*) (1889–1890)
glazed stoneware, height 19″
Collection of Capt. Harry F. Guggenheim, New York

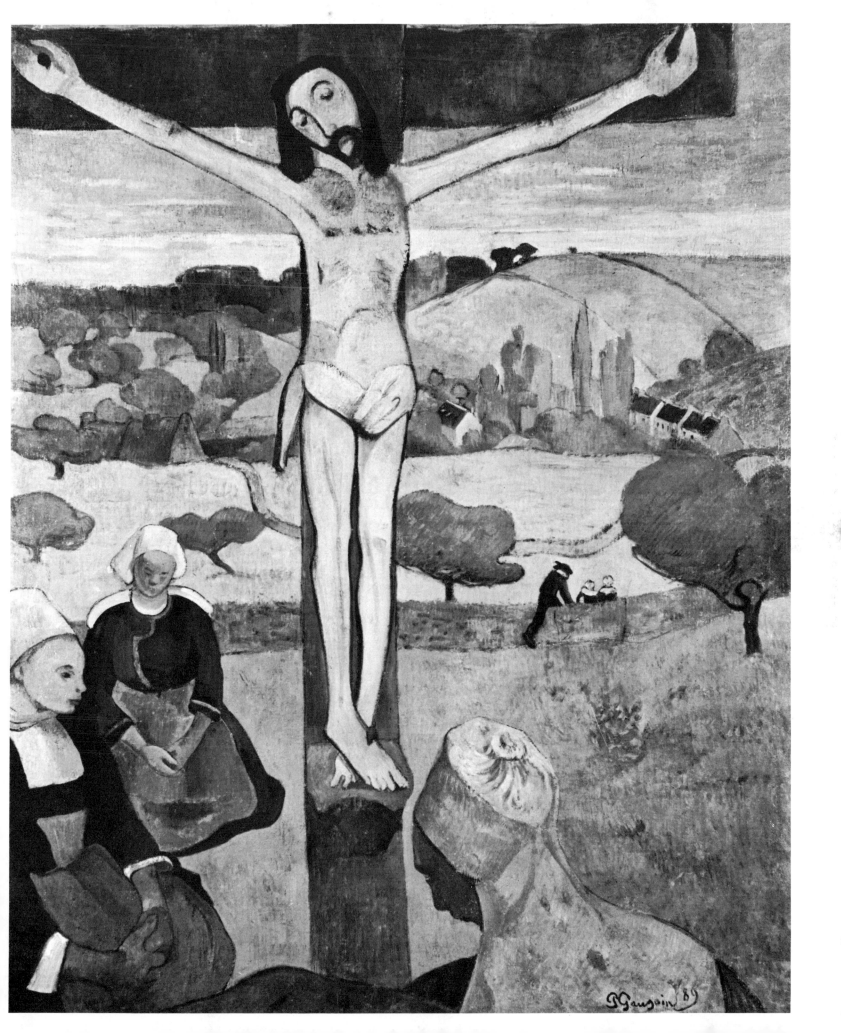

poverty he suffered on the island, nor is there more than a hint that some of the worst features of French colonial administration had begun to wipe out what once may have been a terrestrial paradise of idyllic peace and aboriginal charm. Gauguin might have had enough of Tahiti after this venture, had it not been for a chain of disappointments that made him wish to leave Europe again. Visiting Copenhagen in an attempt towards reconciliation, he found that there was no bridging the gulf that had opened between himself and Mette. On his fourth — and final — stay in Brittany he was severely injured in a brawl with sailors who had insulted his companion, a Javanese girl named Annah. While he was nursing his broken leg at Pont-Aven, Annah, who had gone back to Paris, took advantage of his absence, grabbed everything she could carry away from his apartment, except for the paintings, and disappeared.

He had had enough of Europe. To obtain funds for the second journey to the South Seas, he once again endeavored to sell his paintings at the auction house, the Hôtel Drouot. For greater publicity, he asked August Strindberg, then living in Paris, to write a preface to the catalogue. The Swedish playwright refused: "I can't understand your art and I can't like it. . . . But I know that this avowal will neither astonish nor wound you because you seem to be strengthened rather than otherwise by the hatred of others; your personality, anxious to remain whole, delights in the antipathy it rouses. . . ."

Figure 7.
Pastorales Martinique (ca. 1889)
Zincograph, 7⅜" x 8¾"
Collection,
The Museum of Modern Art,
New York
Lillie P. Bliss Collection

Figure 8.
[opposite page]
Man with an Axe (1891)
oil, 36¼" x 27¼"
Collection,
Mr. and Mrs. Alexander M. Lewyt,
New York

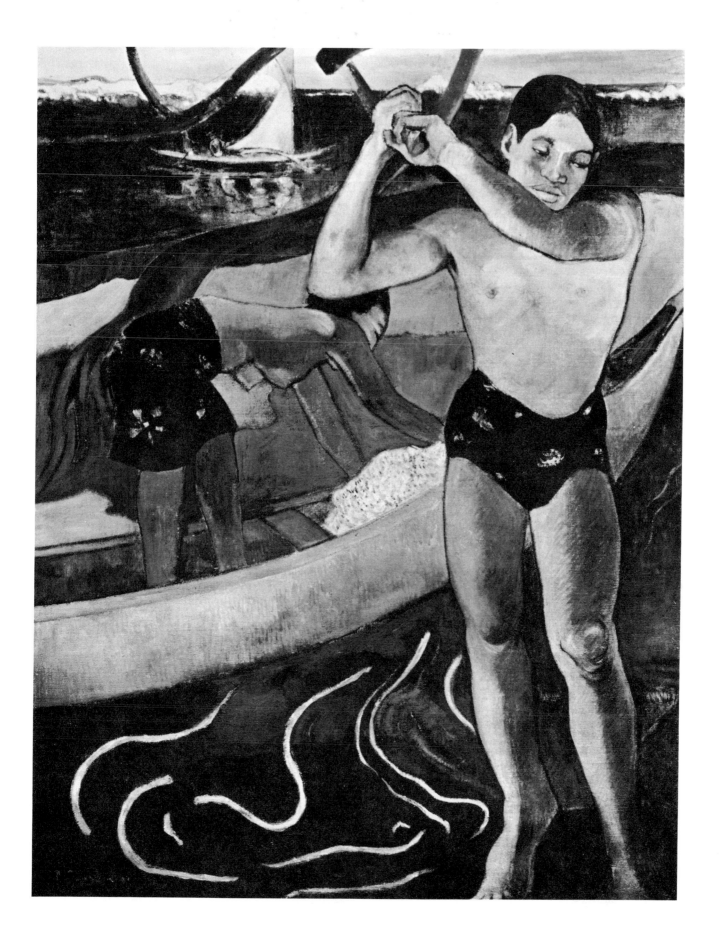

While it was unflattering, Gauguin printed this honest opinion in the catalogue, along with a rejoinder in which he stressed the difference between himself and Strindberg, the "clash between your civilization and my barbarism, a civilization that makes you suffer, a barbarism that rejuvenates me."

Though this action of February 18, 1895 brought disappointingly little, the artist somehow managed to secure for himself a passage to Tahiti. After a lengthy voyage, he arrived there in July. He resumed the kind of life he had led before, again finding a native girl as a companion, and again building a studio in the wilderness, sufficiently far away from the island's noisy capital, Papeete. His output was enormous. But there were few buyers for the pictures he sent to France. He was often sick. A few weeks before his second journey to Oceania he had contracted syphilis, a disease for which no cure had yet been found. At Tahiti news reached him of the death of Aline, the favorite among his children. After finding that Mette would not give up her conviction that he was a "lying, perverted savage" (words she once used to a mutual friend), he finally broke off correspondence with his wife.

His letters to a loyal friend, the painter Daniel de Monfreid, are filled with repetitive complaints about poverty, sickness, the treachery of dealers, and the hostility of critics; at one point he cries out in despair: "When will the time come when we need speak of nothing but art?" By 1897 he was so thoroughly fed up with life that he tried to commit suicide. First, however, he finished what he wanted to be his Testament, the painting *Where Do We Come From? What Are We? Where Are We Going?* (Figure 18). It was so large— almost 15 feet by 5 — that, not having a canvas big enough, he had to use a sackcloth. Thereafter, he took a tremendous dose of arsenic, but it merely gave him "agonizing pains." He recovered and, broke as he was, he had to seek temporary employment as a clerk in the Public Works office at Papeete.

Constantly in debt, and often in the bad grace of the authorities, Gauguin in 1901 decided to remove himself to another, much smaller island, La Dominique (Hiva-Oa in the Maori language) in the Marquesas group, partly because he hoped life there would be less expensive, and also because Tahiti was rapidly losing what was still left of its genuine barbaric charm. But it was unwise for a sick man to go to a place that had no hospital and no regular doctor. Moreover, the Catholic mission there wielded a vast power, and soon the artist and the local bishop were enemies. When his heart gave him trouble and his legs were covered with open sores, Gauguin thought of returning to France, but De Monfreid, who underestimated his friend's sickness — he thought him a hypochondriac — advised him against coming home and so destroying the romantic legend that had already accumulated about him. In April, 1903, Gauguin reported to De Monfreid that he had been sentenced to three months' imprisonment and a stiff fine for having championed the natives against the scandalous treatment of the authorities: "All these worries are killing me."

He had only one friend on Hiva-Oa, a Protestant pastor named Vernier. According to Vernier, Gauguin walked around "dressed like a Maori, Tahitian shirt, colored cloth about his loins, nearly always barefooted." He found him "amiable," though he made a "rather

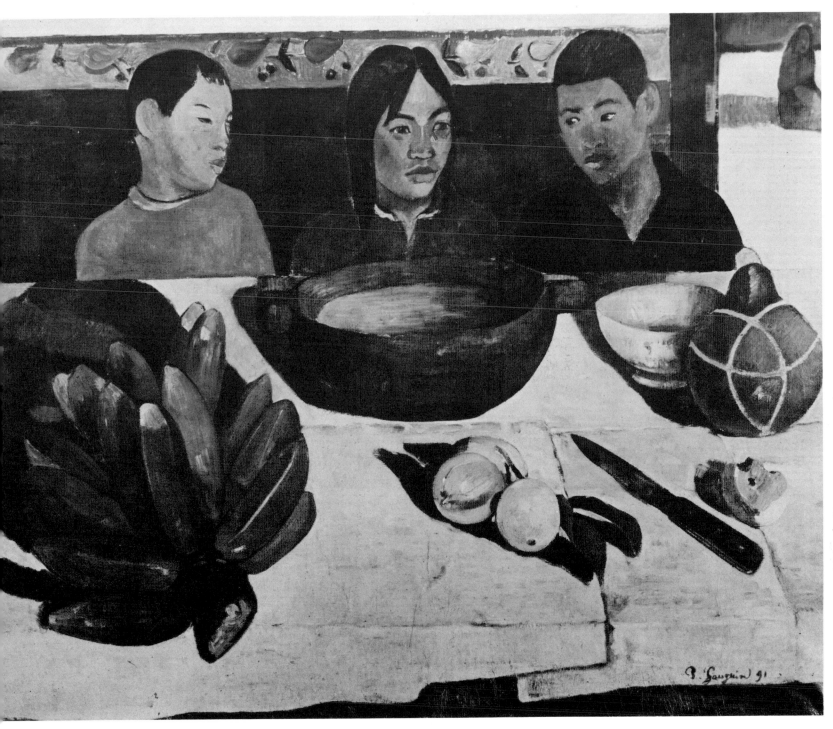

Figure 9.
Le Repas des Jeunes Tahitiens (1891)
oil, 28⅛″ x 35¼″
Louvre, Paris
Collection, Mr. and Mrs. André Meyer

painful impression," with "his legs covered with bandages." When, on May 8, 1903, one month short of his fifty-fifth birthday, Gauguin perished in his hut, the natives — according to Vernier — mourned the death of the man who had often defended them against the police. Gauguin was buried in a small churchyard on a hill above the village of Atuana; on a plain concrete slab with a cement headpiece are inscribed, beneath his name, *"Artiste Francais"* and his dates.

Several months after his passing, the paintings found in his shack on Hiva-Oa were sold in Papeete for anything from a dime to three dollars, to pay the fine that had been imposed on him. Two years earlier, when Gauguin had left Tahiti, a ship chandler in Papeete had bought his shack. Finding three trunks of canvases, drawings, and sculptured pieces, he had them taken out to the reef and their "worthless" contents dumped into the sea.

Today, there is no one left who would deny that Gauguin was one of the outstanding artists of the last century. But was he not also a monster, possessed by a pathological egotism

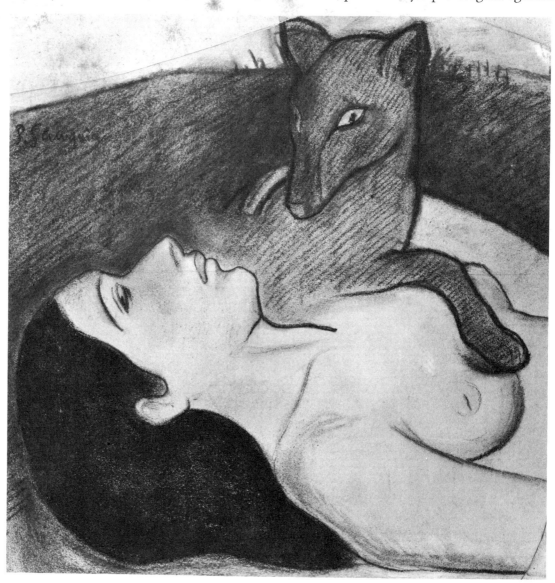

Figure 10.
Woman with a Fox (1891)
crayon, 12¼″ x 12¾″
Collection,
Mr. and Mrs. Leigh B. Block,
Chicago

that stopped at nothing? It may very well have been true that his interest in certain people was determined by the extent to which he could use them. He could be extremely arrogant, and he is known to have remarked, "I have reason for despising a large portion of humanity." He did sacrifice his family's welfare to his artistic goals. This is, perhaps, understandable. But why did he, who had always something of the rascal and adventurer about him, ever try to lead a conventional life, and why did he marry a woman as proper and bourgeois as Mette? At any rate, there is one redeeming feature: he loved his children and suffered terribly from being separated from them. He was sincere when he wrote to Mette: "My business is art; that is my capital, my children's future, the honor of the name I have given them."

Summing up, we must, in any event, give him credit for having been a dedicated artist who had faith in his own genius and who endured years of unbelievable hardship to keep this faith. However unpardonable his departure from Europe may have seemed to Mette,

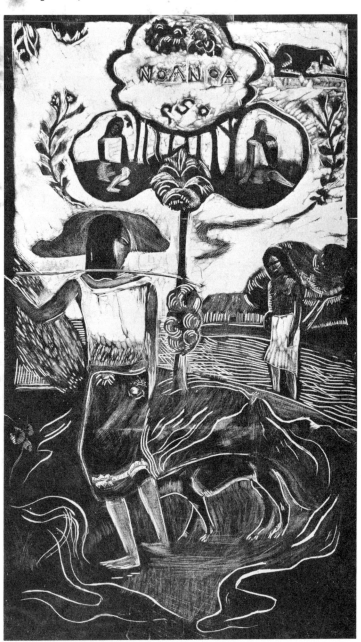

Figure 11.
Noa Noa (ca. 1891–1893)
woodcut, 14″ x 8 1/16″
Fogg Art Museum, Harvard University
Cambridge, Massachusetts

her family and friends, art gained by this first contact of a truly modern man with Oceanic lore. Art through him again became simple, straightforward, monumental — as though Giotto's frescoes had been painted southeast of Eden.

His contributions to painting will be discussed later in some detail. Hence, it might be mentioned here that he was also a gifted sculptor who, at a time when only marble or bronze was fashionable, resorted to wood carving; an able ceramist who, to produce certain aesthetic advantages, deliberately worked his material with his' hands, instead of turning it on the wheel; a draftsman, aquarellist, and print-maker whose woodcuts, often colored, ushered in a revolution in the graphic arts. As readers of *Noa Noa* and the *Intimate Journals* will know, Gauguin, though neither a thoroughly educated man nor a polished writer, had a talent for keen observation, coupled with an unceasing curiosity about the nature of all things, and was able to express himself powerfully in words, without inhibition or restraint.

He even dabbled in journalism. At Papeete, he contributed articles to a monthly anti-church, anti-government newspaper, *Les Guêpes* (The Wasps). Thereafter, he issued, for a brief time, his own little mimeographed paper, *Le Sourire* (The Smile), championing the maltreated islanders. (Few of these sheets, which he decorated with woodcuts of his own, survive; the natives used them for making cigarettes.)

He has been called a noble savage. The stress should be put on the adjective. Often, too often perhaps, he had the need to hide his noble sentiments under eccentric manners. But Gauguin was neither faking nor play-acting when, in a sort of Last Will, addressed to his daughter Aline, he wrote from the South Seas: "I believe in the sanctity of the soul and in the truth of Art, one and indivisible. . . ."

In the 1870s and 1880s no young painter who was not committed to rigid academism could resist the spell of Impressionism. There can be no doubt that when, in the spring of 1874, twenty-nine men and one woman, all more or less unknown, exhibited their works in an obscure studio borrowed from a photographer, the young stockbrokers Gauguin and Schuffenecker saw the show. If they did see it, they were among the small minority who did not jeer at works by Cézanne, Degas, Monet, Morisot, Pissarro, Renoir, and Sisley, to name only those who were to achieve world fame. These two must have read what the angry journalists had written about the exhibition, generally condemned as a horrendous joke. The term "Impressionist," incidentally, was coined by one of these hostile journalists, who had scornfully said about Monet's *Impression, Sunrise:* "Wallpaper in its embryonic state is more finished than that seascape."

Gauguin met the "patriarch" of the group, Pissarro, then forty-four, who invited him to the café where the Impressionists met. He soon became a patron of Pissarro and his associates, and also a pupil of this man, eighteen years his senior, who taught him to observe one of the main tenets of Impressionism — never to paint "except with the three primary colors, red, yellow and blue, and their immediate derivatives." For ten or more years

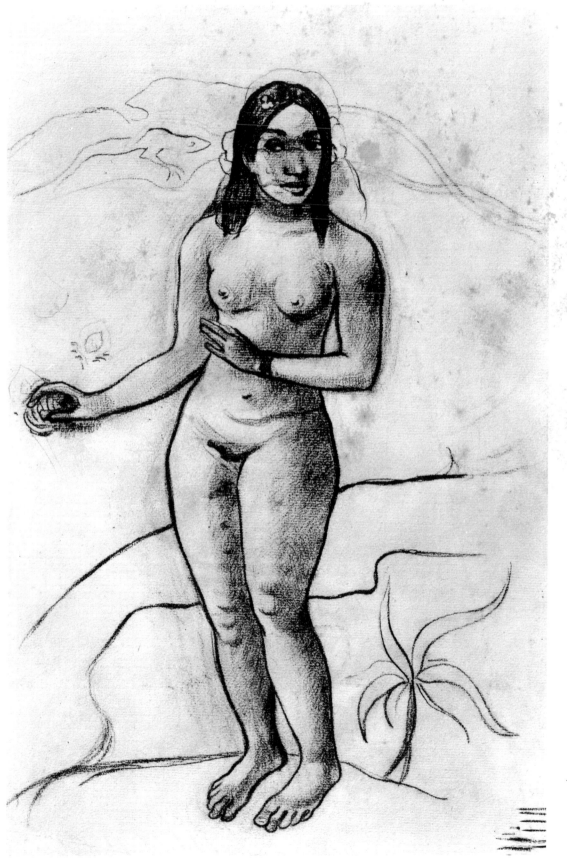

Figure 12.
Nude Tahitian Woman (1892)
recto of a double drawing
17¼″ x 11¼″
Courtesy of
Wildenstein & Co., Inc.

Gauguin allowed himself to be influenced by the aesthetics of his gentle and patient teacher, though the pictures he did are in no case slavish imitations of Pissarro's oils.

What were the Impressionists' specialties?

Defying custom, these revolutionaries replaced the blacks and browns that prevailed in pictures painted in the studio by the pure bright colors found in sunlight (the spectrum or rainbow palette) and reflected upon the fields outside Paris where they planted their easels. These colors they applied on canvas in small touches, juxtaposing, for instance, a red to a blue tone, causing the eye to see a more brilliant violet than any violet mixed on the palette. Luminism, as the movement was also called, tried to capture the sunlight in bright yellows, while shadows were rendered in deep violet. In contrast to the academic painters of France, who sought their motifs in literature, in classical history or mythology, and who did all their work in the dim atmosphere of the atelier, these *plein-air* painters lustily re-created the ever-changing aspects of the natural world around them — meadows, rivers, skies, the villages of the Seine district, and their rustic inhabitants.

For quite a while Gauguin, who in 1879, on Pissarro's insistence, was admitted to an Impressionist group show, and who remained with them until the group's dissolution seven years later, was more or less content with the tenets of his friends. An oil of 1883, *Garden in the Snow* (Ny Carlsberg Glyptothek of Copenhagen), revealed how completely he had absorbed Impressionism, judging by his brushwork, the cut-off view, and especially the color harmony. But by 1886 — the year of the final Impressionist show, in which he showed nineteen paintings done in Rouen, Denmark, and Brittany — he had created landscapes and seascapes indicating that he was about to form an aesthetic of his own, that he was eager to impose his individual inner vision on the sensory data provided by the outer world. As John Rewald has stated it, "Gauguin no longer worked exclusively out-of-doors as Pissarro had taught him, but endeavored now to match his visual with his visionary experiences" (*The History of Impressionism,* New York, 1962).

The liberation from Impressionism, however, made a rapid stride in the following year, 1887, when, during the months Gauguin spent in Martinique, his inherent bent for the decorative was reinforced. Today the term "decorative" is sometimes, but fallaciously, used as a pejorative. Decoration, far from being a weakness, has a legitimate place in an artist's work.

In the tropics, light and color were much stronger, more brilliant than what Monet, Pissarro, and the others encountered under the often cloudy skies in the villages of northern France or in Normandy; and the luxuriant vegetation offered stimuli absent in cooler climates. While it might be an exaggeration to say that Martinique turned Gauguin into the "Post-Impressionist" that he was to remain until his death, the West Indian trip seems to have set free his tendency to flatten and increase the areas of pigment, to simplify outlines, to respond to the opportunity of using unmixed "hot" colors as carriers of strong emotions, to indulge in tapestry-like compositions that do not entirely rely on the offerings and whims of nature. On Martinique, and then particularly in Brittany, during his second,

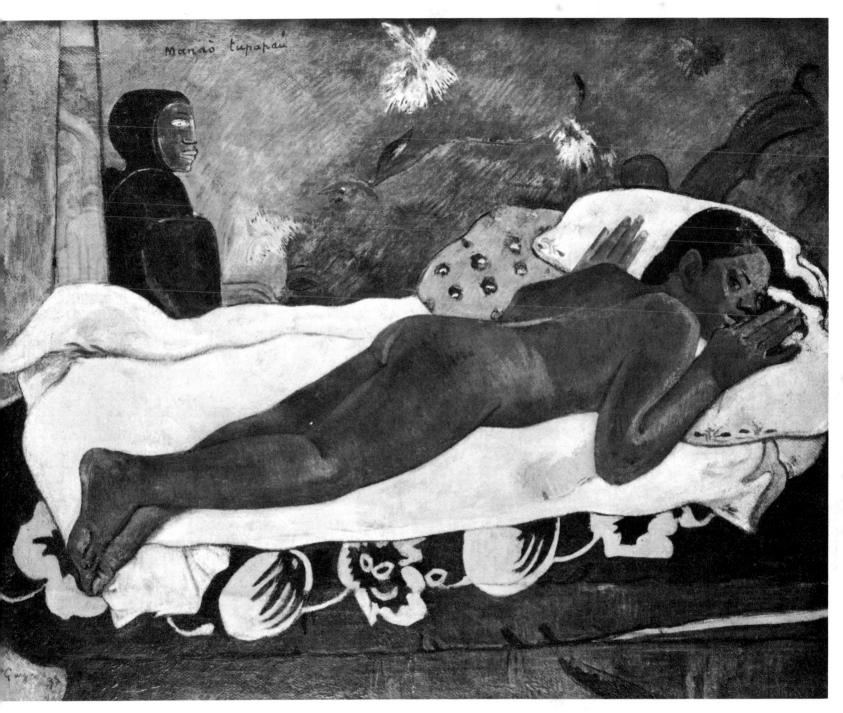

Figure 13.
The Spirit of the Dead Watching (1892)
oil, 28¾" x 36¼"
Albright-Knox Art Gallery, Buffalo, New York
A. Conger Goodyear Collection

most fruitful stay (1888), there was a revolutionary change from the broken brushwork to the smooth, unvarying application of color to definite areas, as a result of an inner change.

By relying upon his interior visions, his emotions, his dreams, rather than on the ready-made vistas that had been the main source for the Impressionists' artistic inspiration, Gauguin, who had begun as one of the lesser members of the group (and who, had he not changed, by now would be little more than a footnote in the history of art), became a leader of what was to become known as Post-Impressionism. However inadequate the term, coined first by the British critic Roger Fry, in 1912, it is now firmly imbedded in the working vocabulary of art historians. It covers the "Holy Trinity" (Cézanne, Gauguin, Van Gogh) as well as a dozen other major figures who, between 1886 and 1905, created bold "anti-Impressionist" pictures. Cézanne summed up his opposition to the Impressionists (with whom he had exhibited on several occasions) by remarking, "Monet is only an eye." (The fact that he added, admiringly, "But what an eye," does not detract much from the severity of his condemnation.)

Gauguin could have said the same thing, and, indeed, he remarked, years before his departure for the South Seas, about Monet and his group: "Their edifice rests upon no solid base . . . they heed only the eye and neglect the mysterious centers of thought." From 1887 onward, one notes in his work an increasing tendency to proceed from a mere transcription of nature to interpretation, and, beyond this, to a rather free use of recognizable elements in nature for the creation of dreamlike compositions. In Tahiti he repudiated everything even remotely related to the more or less "accurate" renderings of nature he himself had produced while still a follower of Pissarro (though he never ceased expressing his gratitude towards his erstwhile teacher). There he declared: "My artistic center is in my brain, and nowhere else, and I am strong because . . . I do what is within me."

What brought about his complete break with Impressionism? Undoubtedly, his own temperament rebelled against the meek acceptance of formulas presented by men older than himself who seemingly sacrificed their souls at the altar of Nature. Whereas the Impressionists were quiet, rational, personally modest men, even though they had caused a "revolution," Gauguin was a restless, unruly creature, with a mystic bent, accompanied by epicurean voluptuousness (he once called himself "a child and a savage"). He found stimuli in aspects of art that did not appeal to, or were ignored by, the Impressionist group. His yearning for what might loosely be called the "primitive" in art led him to cherish the pious and "simple" painters of Italy who were active before the peak of the Renaissance (such as Fra Angelico and Gentile da Fabriano); he was attracted by the flat, decorative designs of Hokusai and other Japanese print-makers (which were also admired by Degas); he was interested in whatever Egyptian, Javanese, or Hindu art reached him, either in the originals or in photographs; folk woodcuts and medieval stained-glass windows also contributed to his conviction that what he wanted to achieve was something higher and better than the realism which had been brought to a climax by the Impressionists.

In the case of quite a few artists, we must deduce their aesthetic theories exclusively

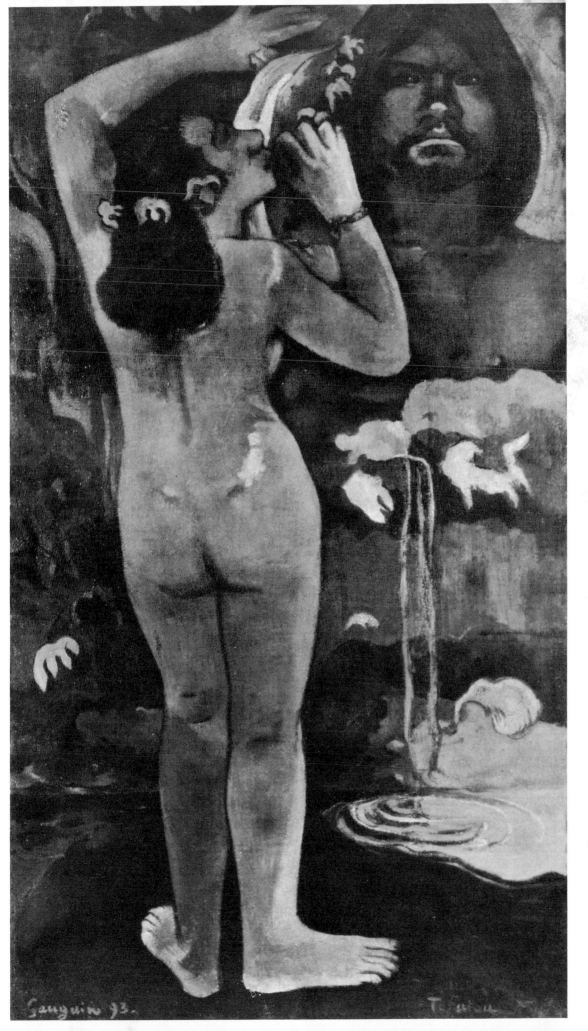

Figure 14.
The Moon and the Earth
(Hina Tefatu), (1893)
oil on burlap, 45″ x 24½″
Collection,
The Museum of Modern Art,
New York
Lillie P. Bliss Collection

from the plastic work they have left, since there are no literary documents of any significance. But Gauguin expounded his views on art in numerous letters and in copious notes assembled during his sojourns in the South Seas. While he was not a systematic thinker, he managed by means of his often aphoristic statements to influence scores of younger men; he is quoted even today (and not infrequently his words are misused to further artistic aims that have little to do with the ideals he himself had held).

Partly to defend his own deviations from the Impressionist practices — his flattening of space, smoothness of surface, broadness of color — and partly to gain followers (he liked to think of himself as the head of an important new school, which, to an extent, he actually was), he went to great lengths to explain what he was after:

"In painting one must search rather for suggestion than for description, as is done in music."

"It is better to paint from memory, for thus your work will be your own: your sensation, your intelligence, and your soul will triumph over the eye of the amateur."

"Do not finish your work too much. An impression [i.e. the immediate impact] is not sufficiently durable for its first freshness to survive a laborious search for infinite detail; in this way you let the lava grow cool and turn boiling blood into a stone. Though it were a ruby, fling it far from you."

Perhaps the quotation that is — for obvious reasons — the favorite of twentieth-century avant-garde artists and critics is one from a letter to Schuffenecker (written by Gauguin in August, 1888, during his second stay in Brittany) : "Don't copy nature too much. Art is an abstraction; derive this abstraction from nature while dreaming before it, and think more of the creation which will result [than of the model]."

"Soul," "mystery," and "suggestion" are among the terms favored by Gauguin, who insisted that he was "not a painter after nature," and who even managed to crystallize his philosophy in these magnificent words: "I shut my eyes in order to see." Though he was skeptical about the value of "isms," it was he who introduced the term *"synthetisme"* into our vocabulary, referring to himself as a "synthetist" as early as 1886. (The broad, simple, "synthetic" lines and colors, the opposite of what the more analytical Impressionists were doing). One critic invented the term *"cloisonnisme"* (from a technique in enamel work of the Middle Ages) to refer to the deep, leadlike lines Gauguin and his group often used to surround forms in a picture. *"Symbolisme,"* also applied by Gauguin and his associates, is borrowed from nineteenth-century French poetry, to emphasize that their pictures were symbols of the imagination rather than mere records of observed fact.

While Gauguin had many detractors, who dismissed his works as "posters," he had also ardent defenders. One was the painter Maurice Denis, who declared that Gauguin was "the undisputed Master, the one whose paradoxical pronouncements were collected and spread, whose talent, eloquence, gestures, physical strength, biting irony, inexhaustible imagination, capacity for alcohol and romantic bearing were generally admired. . . . He wanted above all to catch the character of things, express their 'inner meaning' even in their

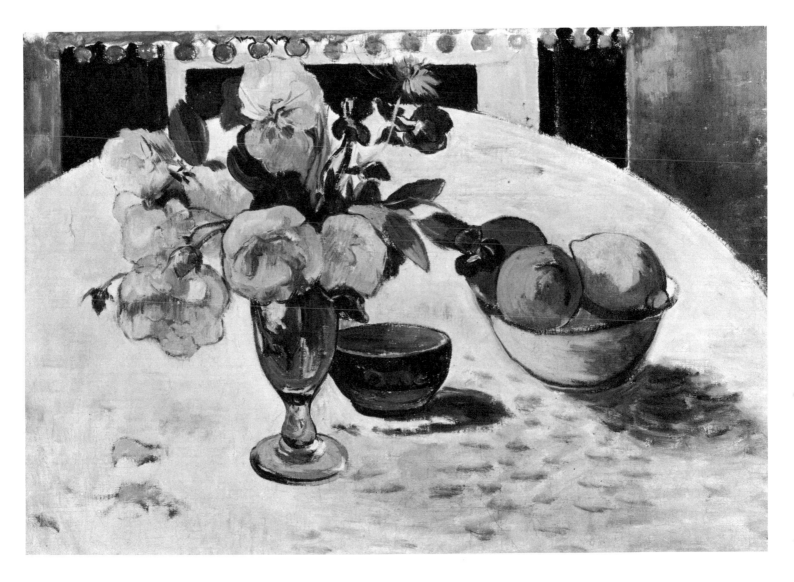

Figure 15.
Still Life:
Flowers and a Bowl of Fruit
(1893) oil, 17″ x 24¾″
Courtesy,
Museum of Fine Arts, Boston
Bequest of John T. Spaulding

ugliness." Another was the astute critic Albert Aurier: "Paul Gauguin seems to me to be the initiator of a new art. The normal and final goal of painting, as of all arts, cannot be the direct presentation of objects. Its ultimate goal is to express ideas by translating them into a special language. To the eyes of the artist, that is to the eyes of him who should be the one who *expresses absolute beings,* objects are valueless merely as objects. They can only appear to him as *signs.*"

Gauguin's influence was not confined to the dozen men who worked with him in Brittany. It also spread to a group of young painters who called themselves *Nabis* (the Hebrew term for prophets), of whom two were to achieve world fame: Pierre Bonnard and Edouard Vuillard. Among his immediate heirs were also the *Fauves* ("Wild Beasts") in France and the *Expressionisten* in Germany. Matisse, an ardent admirer of Gauguin, acquired from the dealer Vollard a work by Gauguin in exchange for one of his own canvases. There can be little doubt that his decorative arabesques, flat tones, and arbitrary colors owe much to Gauguin.

Figure 16.
Porteur de Fei
(Bearer of Bananas)
(1897) woodcut
National Gallery of Art,
Washington, D.C.
Rosenwald Collection

Nearly all of the German Expressionists are indebted to Gauguin, whose works were exhibited in Munich and Berlin soon after 1900. Paula Modersohn-Becker saw his works during her sojourns in Paris. The Swiss, Cuno Amiet, an associate of the German Expressionist group *Die Bruecke,* first went to Pont-Aven in 1892. Gauguin had already left, but his presence was still felt in the inn where he had stayed. Noting there paintings of the entire Pont-Aven school, Amiet spoke of a "strange art, never seen before . . . bright, clear objectivity."

Emil Nolde and Max Pechstein not only admired Gauguin, but even followed his example and went to the South Seas. Kandinsky repeatedly mentioned Gauguin. His own work appears to be an affirmative reply to Gauguin's question, "Why should we not be able to create color-harmonies that correspond to the state of our souls?" With him, Gauguin's prophecy that painting was about to enter the musical phase came true. Gauguin had long before dared to use arbitrary color "to convey the musical sensations which emanate from its very nature." His disciple, Kandinsky, wrote: "Color is the key-board, the eyes are the hammers, the soul is the piano with many strings, the artist is the hand that plays, touching one key or another purposively, to cause vibrations of the soul."

Gauguin, one of those great artists who have knocked at the doors of the world seeking answers, asked questions that are still repeated by artists. Millions have learned from him that a painting (or a sculpture) has its own life, its independent existence as a creation, even if it happens to be inspired by a phenomenon of the visual world.

His influence on art in the United States can be traced back to the Armory show in New York (which also traveled to Chicago and Boston). In this celebrated show, seven of Gauguin's oils, as well as several drawings, watercolors, and a wood sculpture, received places of honor. In 1913, the press was still hostile to him, as it was to all other innovators.

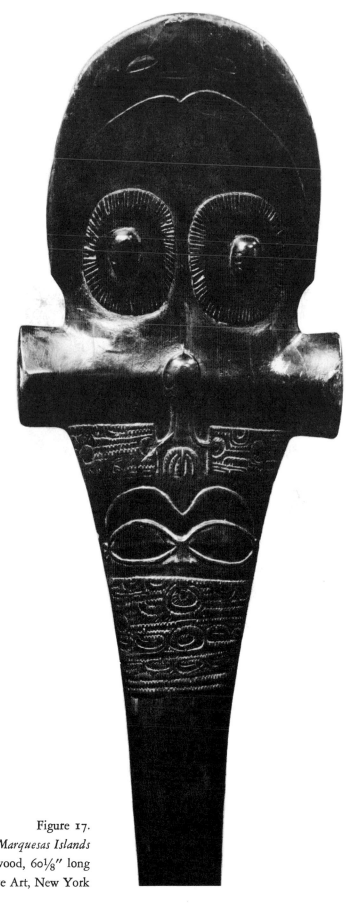

Figure 17.
Top of Staff-Club from the Marquesas Islands
wood, 60⅛″ long
The Museum of Primitive Art, New York

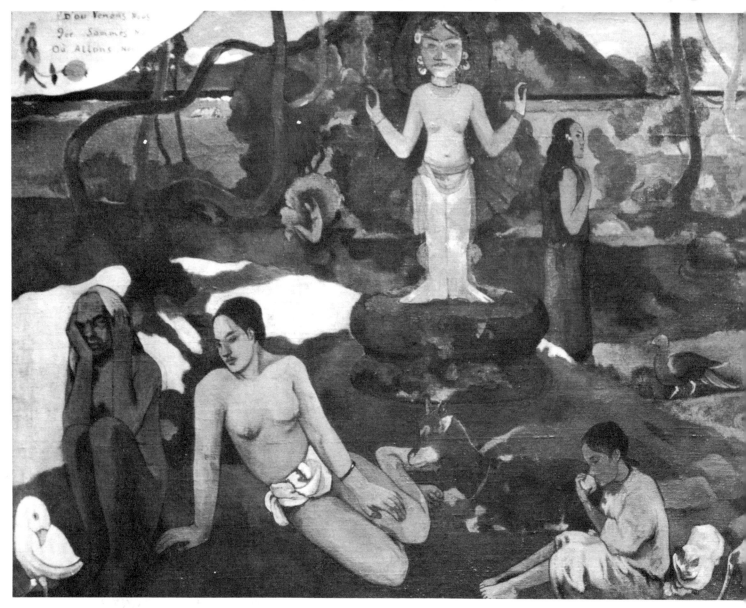

Figure 18.
D'où venons-nous? Que sommes-nous? Où allons-nous?
(1897) oil, 54¾″ x 147½″
Courtesy, Museum of Fine Arts, Boston, Tompkins Collection

One reviewer, who was also well known as an academic painter, dismissed him as a "mediocre technician" who tried to do something he could not accomplish and even as a "decorator tainted with insanity."

In the twenties, however, American resistance to the Post-Impressionists vanished, and by 1929, when New York's Museum of Modern Art devoted its maiden exhibition to Cézanne, Gauguin, Van Gogh, and Seurat, enthusiasm had replaced hostility. There was a constant flow of excellent Gauguins to the United States, climaxed in 1936 by the arrival at Boston's Museum of Fine Arts of one of his most important works, and also his largest, *Where Do We Come From? What Are We? Where Are We Going?*

When in 1959 the Art Institute of Chicago and the Metropolitan Museum of Art in

New York jointly organized a gigantic Gauguin show (comprised of two hundred works
in all media), Theodore Rousseau, Jr., then curator of paintings at the Metropolitan,
summed up the master:

> The high esteem in which Gauguin is held rests on his art itself and his great contribution
> to all of the artists of the twentieth century. It is far too early to know whether his pic-
> tures will always enjoy the high popularity accorded them at the moment; only time and
> the inevitable comparison with the giants of the past can determine it. It is certain, how-
> ever, that he will have an enduring fame as the personality who has exerted the strongest
> influence on modern art. With ferocious courage he asserted his own right to "dare any-
> thing," thereby securing this right for all who came after him. . . . Indeed nearly every
> progressive painter of the last half century at some time in his career has been moved by
> the continuing power of Gauguin.

This last sentence is no overstatement. It is hard to think of any important painter of
our time who was not in some way indebted to Gauguin. To the young artists in Paris,

Figure 19.
Nativity (1902)
oil, 17¼″ x 24⅜″
Private Collection

his work was a revelation when, at last, more than an occasional oil appeared—in the memorial shows, the small one of 1903 at the first Salon d'Automne, and then the large show at the Salon des Independants three years later. Even Pablo Picasso, a more cerebral man and more master draftsman than colorist, was impressed, as is indicated by the Gauguinesque heavy contours in the Blue Period and Rose Period pictures and in certain aspects of *Les Demoiselles d'Avignon.* Just as Gauguin had taken some of his cues from Polynesian art, so Picasso was fascinated by African carvings, and this long before it had become conventional to see aesthetic merit in them. Even the protagonists of some of the more recent trends, such as Action Painting or Hard-Edge painting, owe a debt of gratitude to the liberating force of the color magician, Paul Gauguin, who, on the eve of his death, wrote:

"I wanted to establish the right to dare everything . . . the painters who today profit from this liberty owe me something."

COMMENTARY ON THE SLIDES

COMMENTARY ON THE SLIDES

1: THE SEINE AT THE PONT D'IÉNA (1875), oil, 25⅛″ x 36⅛″, Louvre, Paris

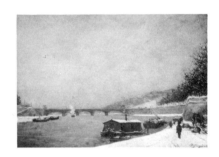

This bridge derives its name from the German city of Jena, where, in 1806, Napoleon administered a crushing defeat to the Prussian army. Gauguin painted this picture four years after he had taken a position with a stockbrokerage firm in Paris, and two years after he had married Mette Sophie Gad. He was still a dilettante, though he had acquired some knowledge of painting, first at the Académie Colarossi, and thereafter working under the supervision of Pissarro. In 1874 Pissarro and other rebels staged what was to be remembered as the first of eight Impressionist group shows. Gauguin was subsequently to participate in five of them.

Gauguin undoubtedly saw this first show, which caused quite a stir, but to judge by this painting does not seem to have been influenced much by the innovators. If this picture—one of the few early works by Gauguin to be found in a public collection—is influenced by any nineteenth-century painter, it might be the Dutch artist Johan Jongkind (1819-1891), noted for the seascapes he painted in the vicinity of Le Havre, and very much accomplished in the rendering of wintry light and open space. In this pre-Impressionist picture, values take precedence over colors. The future "painter of the tropics," later renowned for the glow of his strong, vivid colors, thus began with somber, quiet work, almost drab in its coloration, and still strictly traditional in its perspective. It is interesting that in what may very well have been his last picture, the *Breton Village under Snow* (Slide 20), Gauguin on the South Seas island of La Dominique was to recall the winters of Northern Europe.

2: BRETON PEASANT WOMEN (1888), oil, 28¼″ x 35¾″,
Bavarian State Painting Collections, Munich

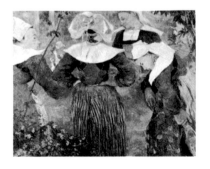

Thirteen years had passed since Gauguin had painted *The Seine at the Pont d'Iéna* (Slide 1). In these years he had acquired pictures by Manet, Cézanne, Pissarro, Renoir, Monet, and Sisley; he had improved his technique; and he had repeatedly shown his work at the official Salon, at Impressionist group shows, and in a short-lived, one-man show in Copenhagen which was closed by order of the local Academy of Art. Yet up to about June, 1886, when the artist first went to Brittany, his work, though pleasing and good in an Impres-

sionist sense, lacked originality. Until the self-liberation which the artist achieved through his confrontation with the relatively primitive population of Brittany and its fascinating, though austere and melancholy nature, he had been a gifted but minor follower of the Impressionists. It was in Brittany that he found himself, step by step shook off Impressionism, and became the revolutionary, the leader of his own school, and thus established himself in the annals of art history.

This painting is one of the fruits of Gauguin's second sojourn at Pont-Aven, to which he retreated after the failure to find peace in Panama or in the West Indies. In Brittany, Gauguin was intrigued by the local costumes (now seldom to be seen except in the smallest communities and even there on festive occasions only). The quaint white headdresses of the Breton women light up this painting. The artist is still faithful to the true colors of the costumes, as an Impressionist would be, and the delicate gradations of tone are also reminiscent of Pissarro and his associates. The delight in the setting has not yet been replaced by emphasis on mysticism and savage features. Yet the concern with decorative patterns—such as the rhythmic repetition in colors and in the women's starched white headdresses—soon to lead to large planes of flat color, clearly stamps this work as Post-Impressionist.

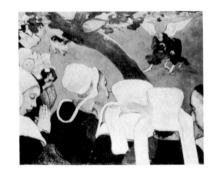

3. The VISION AFTER THE SERMON (also known as *Jacob Wrestling with the Angel*) (1888), oil, 28¾" x 36¼", National Gallery of Scotland, Edinburgh.

The simple Breton village women are wrapt in contemplation of the dramatic scene from the Bible which the parish priest has evoked for them in an eloquent sermon based on: ". . . and there wrestled a man with him [Jacob] until the breaking of the day . . ." (Genesis 32:24).

This picture is far advanced over the *Breton Peasant Women*. It is even more distinctly a Post-Impressionist work: the "real" figures of the priest (lower right) and the seven women are juxtaposed with the two "imaginary" figures of the wrestlers. Each theme is isolated from the other by the diagonally placed tree. Gauguin's new *cloisonné*-like technique appears in the flat areas of color surrounded by strong outlines, especially in the simple treatment of the women. Synthetism, the new doctrine emphasizing the use of broad, simple lines and colors (note, in particular, the large background of evenly applied flaming crimson!) had won over analytical Impressionism.

This is one of a considerable number of pictures on religious themes executed by Gauguin, who, though anti-clerical, was attracted by the mysticism he found in all religious cults. With a friend, he carried the picture from Pont-Aven to the small church at nearby Nizon, offering to donate it out of his wish to see its effect in the old granite building rather than out of piety. The startled priest rejected the gift. What a distinction this obscure church would have acquired, had the picture been accepted!

4: LES ALYSCAMPS (1888), oil, 36¼" x 28¾", Louvre, Paris

Les Alyscamps—a corruption of *"Campi Elissi,"* or Elysian Fields—originally was a Roman cemetery outside what is now the Provençal city of Arles. It remained a burial ground throughout the Christian Middle Ages, consisting of a road lined with sarcophagi and flanked with tall trees. Van Gogh painted Les Alyscamps four times, and there are references to them in his letters to Theo: "These tree trunks are lined like pillars along an avenue where there are rows of old Roman tombs of a blue lilac right and left." He apparently introduced his friend to this motif, but while Van Gogh's pictures clearly described the place in its details, so that it is easily recognizable, Gauguin's picture is more "abstract" —the sarcophagi are not noticeable, though the chapel at the end of the alley is—as the painter concentrated on the flaming hues of the autumn, especially the brilliant yellows and oranges of flowers, bushes, and trees.

Obviously, Gauguin has abandoned Impressionism, native to northern France, where, in the villages along the river Seine, the colors of the landscape were generally soft and subdued under an overcast sky. One might recall that Gauguin's self-liberation had taken place about a year before he was to paint *Les Alyscamps,* while he was sojourning in Panama and thereafter on Martinique. Although he found the longed-for paradise in neither place—he had to work hard at manual labor, and he was afflicted with malaria and dysentery—his eyes were delighted by these tropical landscapes. The deep blue water, the fervently yellow sand, and the exotic trees laden with bright fruit overwhelmed the painter with strong, vivid colors, exaggerated by the brilliance of a glorious sunshine. It was then and there, surrounded by intensities of contrast obliterating nuances, that Gauguin took the decisive step and shed Impressionism's delicate light and shade.

5: LA BELLE ANGÈLE (1889), oil, 36¼" x 28¾", Louvre, Paris

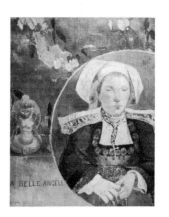

This picture, inscribed *"La Belle Angèle"* and, beneath it, "P. Gauguin '89," contains the portrait of Madame Angèle Satre, who ran a small café next to the Pension Gloanec in Pont-Aven where Gauguin and some of his associates were staying. Her husband, who at one time served as mayor of Pont-Aven, asked Gauguin to paint a portrait of his wife. After each session, the artist would cover the picture, refusing even a glimpse to his sitter. When he had finished his work and wanted to present it to the lady, she exclaimed, "What a horror!" and would not have it. Gauguin, however, was entirely pleased with the work. The dealer Theo van Gogh, to whom Gauguin had sent it, along with other pictures, also liked it. In a letter to his brother, Vincent, he wrote:

> "It is a portrait put down on the canvas like the big heads in the Japanese crépons designs on fine cloth; there is the bust-portrait with its outlines and then the background. It is a Breton woman, seated, the hands folded, black dress, lilac apron, and a white ruff; the outlines are gray and the background of a beautiful blue lilac with pink and red

flowers. The expression of the head and the attitude are very well found. The woman is somewhat like a young cow, but there is something so pleasant to see." (*The Complete Letters of Vincent van Gogh,* Vol. III, New York, 1959)

Next to the sitter, to the left of the circular inset in which he placed her, Gauguin put what appears to be a Peruvian fertility goddess. The husband of Angèle was enraged because he believed this image of a pre-Columbian work to be a caricature of himself.

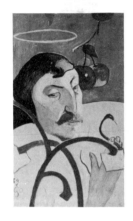

6: SELF-PORTRAIT (1889), oil 31¼" x 20¼", National Gallery of Art, Washington, D.C., (Chester Dale Collection)

Of the many reasons urging an artist to paint his self-portrait, two seem particularly compelling. One is his desire to express his concern with his ego, with that dark, mysterious hinterland of the mind that he is eager to explore with pencil or brush. Another is his wish to say to posterity: "Look at me. This was the man who struggled, unappreciated by the multitude, living in a dream world of his own—if not a saint, at least a martyr, eager to present his feelings, his thoughts, without compromise." Virtually every painter, even an abstract one, has left us at least one self-portrait. The Impressionists have produced self-portraits, yet these are not necessarily their best works, as their major concern was directed towards landscape. Self-portraits as human documents recur frequently among the Post-Impressionists, especially Cézanne, Gauguin, and Van Gogh.

Like his friend Van Gogh, Gauguin has left self-portraits too numerous to mention here. *Self-Portrait before an Easel* (1883, in a private collection in Berne, Switzerland) shows the artist healthy and confident, in a dark, somewhat academic painting. The self-portrait of 1888, in the collection of Van Gogh's nephew in Holland, has *"les miserables"* written below a dedication to Vincent, and in the upper right corner a profile of their younger colleague Emile Bernard. Another important self-portrait by Gauguin was done in 1890, where the artist poses between his painting, *The Yellow Christ,* and a primitive mask (this picture for a long time belonged to one of Gauguin's admirers, the painter Maurice Denis).

In the present self-portrait the artist portrays himself with a halo, which suggests that he, as the leader of a new movement, a new school, considered himself an exceptional being, scorned and derided as is everyone who offers new visions, new ideas.

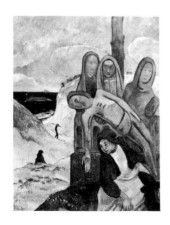

7: BRETON CALVARY (also known as *The Green Christ*) (1889), oil, 36¼" x 28¾", Royal Museums of Fine Arts, Brussels

"Calvary" is the English rendering of the Latin *calvaria* (skull) in the Vulgate, the earliest Latin version of the Bible. The word represents the Hebrew *Golgotha* (according to Matthew 27:33 "a place of a skull") and refers to the spot outside Jerusalem where, according to the Gospels, Jesus was crucified. "Calvary" is also the term used for a sculptural

38

representation in the open air of the Crucifixion—or another scene from Christ's life—designed to serve a local priest in the instruction of illiterate peasants. The celebrated Calvaries of Brittany, dating from about 1450 to 1650—the astonishing work of simple stonemasons—can be found chiefly in Basse Bretagne, the westernmost, more primitive part of the Breton peninsula, which includes the villages where Gauguin and his friends were working. A recent map indicates that twenty-two stone Calvaries are still standing in this region.

The one at Brasparts, some miles north of the city of Quimper, served as inspiration for Gauguin's picture here. In the Calvary of Brasparts, the three Marys holding Christ's body on their laps are forming an austere unit. St. George is seen at the foot of the central cross. Gauguin followed this concept rather closely in the *Breton Calvary*, except that in lieu of the Saint a Breton woman, immersed in thought, is seated before the greenish sculptured group. This somber, shadowy Pietà stands ghostlike before the sunlit coastal landscape (the model at Brasparts is actually located in the interior, a long stretch away from the ocean). A stark contrast is created by the melancholy chromatics of the sculpture and the cheerful colors of meadow, sky, and sea. The alternative title, *The Green Christ,* distinguishes this picture from *The Yellow Christ* (see Figure 6), which is also derived from a primitive Breton religious work, the wooden crucifix in the sixteenth-century chapel at Tremalo, near Pont-Aven.

8: NIRVANA (*Portrait of Meijer de Haan*) (ca. 1890),
gouache, 8½″ x 11⅛″, Wadsworth Atheneum, Hartford, Connecticut

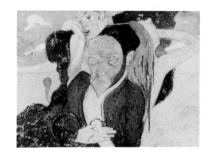

The word "Nirvana," written in the lower right corner, is taken from Buddhist theology and means, literally, "blowing out" or "dying out." It refers to a calm or sinless state or condition of mind, attained through the dying out or extinction of sin. When this emancipation is reached by the individual, passion, hatred, delusion, pain, and even outward reality no longer exist for him. The figure in the foreground seems to have reached this stage. He is the painter Jakob Meijer de Haan (1852–1895), a Dutch Jew from a rich mercantile family in Amsterdam who became one of Gauguin's most ardent disciples in Brittany, and even contributed to his master's support. Gauguin harbored the hope that De Haan would accompany him to the South Seas, but De Haan's family threatened to stop his monthly allowance if he continued his association with Gauguin, and he received no money for the passage.

The dwarfed hunchback De Haan appears repeatedly in Gauguin's work (see, for instance, *Contes Barbares,* Slide 18). His protruding forehead, bulging eyes, and pug nose seem to be caricatured. The large arabesque he holds in his hand forms a G, and "auguin" is written, in small letters, on the hand. Oblivious of everything around him, the sitter pays no attention to the two women in the background whose gestures are meant to express

anguish. The belief in Nirvana was promulgated by the German philosopher Arthur Schopenhauer, whose writings were popular among French intellectuals in the second half of the last century, and whose ideas may have reached the painter through conversations with well-read friends. Schopenhauer maintained that the only philosophical solution for the anguish of life lay in achieving Nirvana.

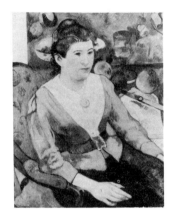

9: PORTRAIT OF MARIE DERRIEN (1890), oil, 25⅝" x 21½",
The Art Institute of Chicago (Joseph Winterbotham Collection), Chicago, Illinois

This picture was formerly regarded as a portrait of Marie Henry, mistress of the inn at Le Pouldu, in Brittany, where Gauguin stayed with some of his colleagues. But the sitter is actually another local woman, Marie Derrien, nicknamed Marie "Lagadu," or "Black Eye," in the Breton dialect. In this picture, Gauguin pays homage to Paul Cézanne, nine years his senior, who did not care for the extrovert Gauguin, seeing in him only a cunning dilettante who had stolen his formula. "Don't talk to me about Gauguin," he once chided a friend. "I'd like to wring the fellow's neck." Here, much reminds us of Cézanne's portraits: the diagonal placement of the sitter, the solidity, the angular rhythms, the expressionless face.

Cézanne, disliking Gauguin's lack of modeling and gradation, asserted that Gauguin was not really a painter but a producer of "Chinese images," a reference to Gauguin's flat and weightless silhouettes. Nevertheless, Gauguin revered Cézanne and owned several of his works. In the background of the present picture, considerably exaggerated in size, is Cézanne's *Still Life with Compotier,* painted 1879–1882 and now in a private collection in Paris. When Gauguin's friend and colleague Schuffenecker offered to buy the Cézanne picture from him, the artist, though in straitened financial circumstances, declined, saing that he had refused an earlier offer of 300 francs—not a small sum—for this "exc´ tional pearl."

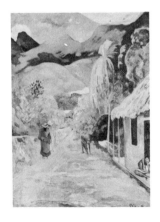

10: STREET IN TAHITI (1891), oil, 45½" x 34⅞",
The Toledo Museum of Art, Toledo, Ohio, (Gift of Edward Drummond Libbey)

Here the artist unexpectedly reverts to linear perspective as practiced by tradition-bound artists. Yet the colors are stronger and more glowing than on any of the canvases created by other artists of that time. One gathers how excited the painter was by the fresh, vibrant, pure colors of this tropical island, and how fascinated he was by the luxurious vegetation, the exotic fruits, the dazzling flowers. This is clearly not a street in the downtown section of the Frenchified capital, Papeete, but one leading to the untouched core in the center of Tahiti.

In his journal, *Noa Noa,* which was edited for publication by his friend Charles Morice, Gauguin wrote: "One must know how to climb the tall trees, how to go into the mountains, in order to return weighed down with heavy booty. . . ." Guided by a native, he made an expedition into the interior, on a path along a brook: "It leads through a confusion of trees—breadfruit, ironwood, pandanus, bouraos, coconut, hibiscus, guava, giant-ferns. It is a mad vegetation, growing always wilder, more entangled, denser, until, as we ascend toward the center of the island, it has become an almost impenetrable thicket."

He also wrote: "I can understand why these people can remain for hours, days even, seated on the ground in silence, in melancholy contemplation of the sky." Such a figure in contemplation is the woman squatting beneath the straw roof of the hut. She reappears in two other canvases, *Te Faa Turuma* (The Brooding Woman) and *Te Reriora* (The Nightmare). Having left a metropolis, where everyone seemed to be rushing about in a mad scramble for success, Gauguin was highly appreciative of a people who seemed to be capable of achieving wisdom, or at least serenity, through absorption in thought for its own sake.

11: REVERIE (1891), oil, 37" x 26¼",
Nelson Gallery—Atkins Museum (Nelson Fund), Kansas City, Missouri

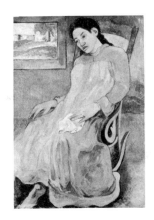

This picture is also known under the title *Mélancolique.* There appears to be a discrepancy between the Polynesians as described by Gauguin in *Noa Noa*—happy people who like to sing or to tell humorous stories—and those in his paintings, who often have melancholy expressions. In all likelihood, they are subject to abrupt mood swings. His companion and model, Tehura, who posed for many other pictures as well, is thus characterized in *Noa Noa:* "My wife is not very talkative; she is at the same time full of laughter and melancholy. . . ." Four years after this picture was painted, in a letter addressed to the Swedish playwright August Strindberg, he praised the Eve of a primitive civilization at the expense of the European Eve "who makes nearly all of us misogynists." But his Eve does not appear here to be a spontaneous, cheerful child of nature. In fact, her mournfulness has an ominous, foreboding quality.

Teha'amana, whom Gauguin called Tehura in *Noa Noa,* was actually only about thirteen when she lived with the painter as his *vahine.* According to his reports, she knew "all the gods of the Maori Olympus by heart," and even gave him "a full course in Tahitian theology" as they were resting together in their bed. It has been pointed out, however, that a young girl was unlikely to have all this knowledge, particularly since the Polynesians withheld all details of religious rites from women.

Note the modulations of reds, filling about half of the picture. While the woman, the chair, and the painting on the wall (an unidentified work by Gauguin, probably a Breton farm scene) are done in a more or less realistic vein, no attempt is made to give the floor

and the wall any definition through conventional recession or shading. Thus the sitter and her chair seem to exist in isolation, as if in a dream. One recalls the paintings of Modigliani in which nothing is done to clarify the background.

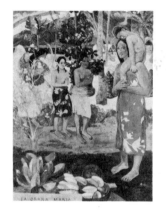

12: IA ORANA MARIA (*We Greet Thee Mary*) (1891), oil, 44¾" x 34½", The Metropolitan Museum of Art, New York (Bequest of Samuel A. Lewisohn, 1951)

In a letter to his friend Daniel de Monfreid, the artist referred to this picture: ". . . I have done one painting, an angel with yellow wings presents two Tahitian women, half-dressed in *pareos,* a sort of flowered cotton fabric that is worn as you like and hangs from the waist, to the figures of Mary and Jesus, who are also Tahitians. Very dark mountain background and trees in flower—dark violet path and foreground emerald green; with bananas on the left—I am very pleased with it" (March, 1892).

As mentioned before (in the commentary on *Vision after the Sermon,* Slide 3), Gauguin, although hardly a religious person in the accepted sense of the term, did concern himself with topics inspired by the Scriptures. Whereas *Jacob Wrestling with the Angel* is placed in a Breton setting, this version of the Adoration of the Shepherds is framed by the luxuriance of the tropics, and the *dramatis personae* are Polynesians. (Gauguin assumed —and art history bears him out—that simple people, such as the natives of Tahiti, imagine Biblical figures to be folks like themselves.) The winged angel is, of course, a concept introduced by the missionaries, who also taught the islanders to fold their hands while praying. Mary, carrying her son on her shoulder, is a typical Tahitian woman; only the rather inconspicuous halos around their heads identify mother and child as saintly figures.

There is a subtle contrast of flat, uniformly colored surfaces with some more softly modeled details. The great simplicity of postures combines with the rich flow of the exotic garments and nature to make this an unforgettable picture which, indeed, exudes a religious feeling. The critic Achille Delaroche was excited when he saw it exhibited at the firm of Durand-Ruel: ". . . a stained-glass window full of richly colored flowers, human flowers and flowers of plants. . . . Supernatural vegetation that prays, flesh that blooms on the shadowy border between the conscious and unconscious" (quoted in *Paul Gauguin's Intimate Journals,* Bloomington, Indiana, 1958).

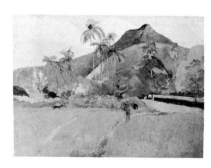

13: TAHITIAN LANDSCAPE (1891), oil, 26¾" x 36⅜", The Minneapolis Institute of Arts, Minneapolis, Minnesota

This picture, like *Street in Tahiti* (Slide 10), is dominated by high mountains. The island is mountainous except for a narrow strip of habitable and arable land along the seashore.

42

The colors in nature here are, undoubtedly, much stronger than they are in temperate zones. Gauguin himself wrote in *Noa Noa* that the bold intense colors of Tahiti dazzled and blinded him. Still, there can be no doubt that Gauguin deliberately intensified them in his paintings much as he did earlier in his landscapes of Brittany, Martinique, and Arles. The flamboyant color clearly anticipates the *Fauves* (the "Wild Beasts") led by Henri Matisse thirteen or fourteen years later.

Gauguin understood the emotive power of colors years before setting foot in Tahiti. In Brittany he advised his disciples: "How does that tree look to you? Green? All right then, use green, the greenest green on your palette. And that shadow, a little bluish? Don't be afraid. Paint it as blue as you can."

He anticipated what Kandinsky and other twentieth-century rebels were to formulate concerning the interior emotion, as symbolized by color, when he wrote: "Color, being an enigmatic thing in the sensations it gives us, can logically only be used enigmatically every time it is employed, not for drawing but for giving the musical sensations which proceed out of its own nature, its own interior, mysterious, enigmatic force."

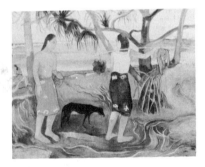

14: UNDER THE PANDANUS (1891), oil, 28¾" x 36",
The Minneapolis Institute of Arts, Minneapolis, Minnesota

"Pandanus" refers to tropical trees and shrubs, on the islands of the Malay Archipelago and the Indian and Pacific Oceans, that have a palmlike or branched stem, long, narrow, rigid, spirally arranged leaves, aerial roots, and edible fruit. The title, in the native tongue, is *I Raro Te Oviri*.

After escaping Europe and its artistic traditions, in an increasing measure the artist used brilliant, unreal colors. Here everything is stylized, and a Baroque, or rather Art Nouveau design created through the interplay of curves and anti-curves. A rhythmical pattern is made by the combination of verticals—the two native women, echoed by the trunks of the trees, the sinuous lines in the foreground—and by the horizontals created by the beach line and the horizon.

This picture is one of eight canvases listed in the artist's letter to his wife, dated December 8, 1892. He writes that they had been shipped to his friend and trusted agent Daniel de Monfreid in Paris. (They were to be exhibited in Copenhagen, but the show was probably never held.) He gives her the Polynesian titles and the French translation, but warns her: "This translation is for you only so that you may give it to those who ask for it. But I want the titles in the catalogue to be the same as on the pictures. This language is fantastic and has several meanings." He adds: "Many of the pictures, of course, will be incomprehensible and you will have something to amuse you."

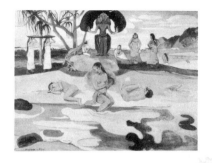

15: THE DAY OF THE GOD (*Mahana no Atua*) (1894), oil 27⅜″ x 35⅝″,
The Art Institute of Chicago (Helen Birch Bartlett Memorial Collection), Chicago, Illinois

This exotic, almost uncanny scene is dominated by the idol with his strange feather head-dress. He is Taaroa, the creator of the world and the major figure of the Maori pantheon. In his honor, two white-clad maidens carry in gifts (on the left); two girls are performing a sacred dance (on the right). To the left of the idol, a musician plays a flutelike instrument; to the right, a woman caresses her little child. In the middle is a group of three nude figures. The water in the foreground is filled with curious shapes. The trees at the upper left are very similar to those in *Under the Pandanus* (Slide 14). Everything looks very much staged; at any rate, Gauguin could not have observed such a scene (if a ritual of this kind was ever performed), since the Tahitians had given up their indigenous religion, and, at least outwardly, had become Christians long before the artist arrived on the island.

This picture recalls Gauguin's admiration for a much older colleague, Pierre Cécile Puvis de Chavannes (1824–1898), whose allegorical symbolism and disdain of the matter-of-fact realism of a Courbet set the stage for Gauguin's work with its tapestry-like flatness, restful balance, and monumental spaciousness. Gauguin was impressed by the *Poor Fisherman* of Puvis which critics attacked because of its "naive stiffness" and an "affected primitive awkwardness." The influence of ancient Egyptian art is also noticeable in the gift-carrying, white-clad maidens who seem to come from the walls of an Egyptian temple. On the other hand, the curled-up women in the foreground anticipate certain figures in the pastorals Matisse was to paint around 1905, at the height of the *Fauve* era.

16: TWO TAHITIAN WOMEN (*Femmes aux Mangos*) (1889), oil, 37″ x 28¾″,
The Metropolitan Museum of Art, New York (Gift of William Church Osborn, 1949)

"Mango," an East Indian word, is an evergreen tree native to tropical Asia. In flower it has thick clusters of small yellow or reddish blossoms. Its fruit is sweet and fragrant.

In the South Seas Tahitian women Gauguin found the exotic loveliness he was seeking—chaste and yet sensuous; dark bodies full of promise, large eyes full of mystery. Here at last was Eve, innocent even of the notion of sin. Her charms are offered to our gaze as freely as the tropical flowers. Gauguin's standards of beauty differed from those of other nineteenth century French painters. The name of Ingres stands for the cold perfection of virginal nudes; Delacroix painted enticing oriental odalisques; Courbet, the carnal flamboyance of heavy-set models; Renoir, the voluptuous charm of buxom girls; Seurat, slim models with no trace of sensuality; Degas, the angular, not yet fully developed bodies of young dancers; and Toulouse-Lautrec, the depravity of prostitutes. Gauguin loved and admired the erect stature of the broad-shouldered, healthy Polynesian women, who combined strength with grace.

44

It has been established that the poses of the two women in this picture are derived from the frieze of the Javanese temple at Boro Badur. In all likelihood, Gauguin acquired a photograph of this frieze after a visit to the Exposition Universelle (Paris, 1889), which acquainted him with a good deal of exotic art. "Have always before you the Persians, the Cambodians, and a little of the Egyptians," he once advised his disciples. On the walls of his Polynesian huts he placed reproductions of art, past and present, to derive inspiration from mankind's heritage and combine it with his own unique imagination.

17: RIDERS ON THE BEACH (1902), oil, 25⅞″ x 29⅞″,
Museum Folkwang, Essen, Germany

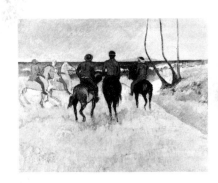

Settled in a native hut at the large village of Atuana on Hiva-Oa, Gauguin could see from his doorway the beach and the open sea. A picture very similar to this, with an identical title, is in a private collection. It is slightly larger, and, in addition to the five male riders, has a woman on horseback, talking to another woman standing on the ground. Horsemen and horses, topics which so fascinated Edgar Degas—whom Gauguin admired, and who was one of Gauguin's few patrons—are rarely to be found in the work of the younger master. There are two riders and a riderless horse in *The White Horse* (1898, the Louvre), and a nude rider on a dark horse is included in *Faa Iheihe* (*Preparation for the Feast,* also 1898, the Tate Gallery, London). A woman on a white horse is to be seen in *Three Women and a White Horse* (1903, Museum of Fine Arts, Boston).

While both animals and men are accurately drawn, the absence of shadows is noticeable here, as it is in the majority of Gauguin's works from his maturity. The strong, "unnatural" pink of the beach—which covers half of the picture's area—again forecasts the *Fauves,* who were familiar with Gauguin's work and came into prominence two years after his death in 1903.

18: CONTES BARBARES (1902), oil, 54¼″ x 35½″,
Museum Folkwang, Essen, Germany

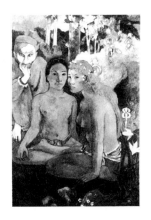

Contes Barbares means "Tales of the Barbarians." A picture with a similar title, *Poèmes Barbares* (1896), painted in Tahiti, showing a half-nude native woman lost in reverie beside a small idol, is in the Fogg Art Museum of Harvard University in Cambridge, Massachusetts. This *Contes Barbares,* however, was done later, on Hiva-Oa (La Dominique), where Gauguin arrived in September, 1921. Six months passed before he started to work again. In the "House of Pleasure" he built for himself in the village of Atuana, Gauguin, despite his shaky and rapidly deteriorating health, painted some of his finest pictures. He was enamored of the beauty of the slim, golden-skinned Marquesan women: "I assure you that

from the point of view of painting, it is *admirable,*" he wrote to De Monfreid. "Such marvelous models! Here poetry emerges of its own accord, and it is enough to let oneself dream while painting, to suggest it."

The term "barbarian," of Greek origin, referred to any non-Greek. In later usage, the word was applied to people between the fierce savage and the civilized man. To Gauguin, at any rate, the word had no pejorative implication. He was fond of the "barbarians" on the South Seas island; he loved them, respected them, and easily won them over by his sympathy and generosity. Earlier, from Tahiti, he had reported to his wife: "They sing; they never steal; my door is never closed; they do not kill. . . ."

On Hiva-Oa, Gauguin's favorite model was a young, red-headed matron named Tohotaua, who here is seen on the right. The crouched storyteller in blue, deformed and with clawed feet, is the unfortunate dwarfed painter Jakob Meijer de Haan, who appears in *Nirvana* (Slide 8). When he painted this, from memory, Gauguin was probably not aware that his loyal and devoted friend had died prematurely at Amsterdam seven years earlier. It has been suggested that by juxtaposing the ugly De Haan to these two good-looking young Polynesians, Gauguin sought to compare the loveliness of the new world to the hideousness of the old.

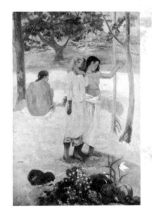

19: L'APPEL (*The Call*) (1922), oil, 51¼" x 35½", The Cleveland Museum of Art (Gift of Hanna Fund and Leonard C. Hanna, Jr.,) Cleveland, Ohio.

"You have no idea of the peacefulness and solitude of my life here," Gauguin wrote to De Monfreid, "all alone, surrounded by vegetation." Gone was the cocksureness, the arrogance of earlier years, for he added, in a spirit of great humility: "I ask only two years of health and not too much trouble about money . . . so that I may reach a certain maturity in my art." He had only one year to live, and it was one of unceasing illness and constant financial worry. Nonetheless, the work he created in his final stage is superb from every point of view, and is so serene, so well balanced that one must think that as long as he stood before his easel he found surcease from his misfortune. Among the pictures he made in that year are those reproduced on Slides 17 to 20, as well as the famous *And the Gold of their Bodies* (in the Jeu de Paume, the Louvre).

This picture is full of mystery. Since Gauguin had stopped commenting on his pictures, as he had done previously in letters to his wife or his friends, we shall never know what, for instance, the semi-nude woman is about to point out to her fully dressed companion. The picture, while less stylized than his other South Seas works, is loaded with spirituality. Here, pinks and reds and violets prevail, not in flat colors but in the modulations by short parallel hatchings that were characteristic of his earlier work. In this enigmatic picture, the artist faithfully follows his principle: he does not describe, he offers suggestions, hints.

20: BRETON VILLAGE UNDER SNOW (1903), oil, 25½" x 35¼",
Louvre, Paris

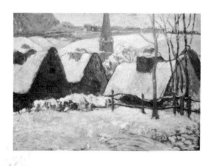

The four months and a week which Gauguin was to live in 1903 were very bad for the artist. Early in the year the Pacific islands were hit by a cyclone. Then the French authorities condemned the artist to three months' imprisonment and a stiff fine for his defense of the natives, who, he believed, were exploited and maltreated by the colonial power. And beyond this his illness was accompanied by the most excruciating pains. "All these worries are killing me," he wrote to his friend, De Monfreid, in April.

Under these circumstances, he strongly felt the approach of that "ship of the sun" which, according to Polynesian mythology, comes for the dead and bears them off to the other side. It is not surprising, then, that the unhappy man looked back nostalgically to his sojourns in Brittany (he had last been there in 1894, prior to his second and final journey to Tahiti). This picture, muted in colors as is the first in this book (Slide 1), strangely harks back to Impressionism and even earlier, traditional styles.

Gauguin died on May 8, 1903. One may speculate on how his art might have developed, had he returned to France and received proper medical care, which was unavailable on Hiva-Oa. His life might very well have been prolonged by several years. Would his restless mind have found new avenues of expression — or would he have reverted to earlier styles and earlier subject matter? Or, half a world away from the stimulating atmosphere of the South Seas, would he have produced watered-down versions of the great canvases painted on Tahiti and Hiva-Oa? One can only speculate. However, it seems likely that De Monfreid gave Gauguin the soundest advice when he urged him to stay on in Polynesia, come what may, lest he destroy what, indeed, had become a great legend.